MW01078742

Celtic Design
and
Ornament
for
Calligraphers

céad
míle
fáilte

Celtic Design

and

Ornament

for

Calligraphers

Jack Mackinder

Thames and Hudson

Acknowledgments

Robert D. Stevick, for permission to use some of his diagrams, Iain M. Bain, for permission to illustrate his method for drawing key patterns, Dean Huston of Olson Manufacturing & Distribution, Inc., for permission to illustrate the Ames® Lettering Guide and Bub Bridger, for permission to write out one of her poems (Long John Montgomery © 1989 Bub Bridger).

Any copy of this book issued by the publisher as a paperback is sold subject to the condition that it shall not by way of trade or otherwise be lent, resold, hired out or otherwise circulated without the publisher's prior consent in any form of binding or cover other than that in which it is published and without a similar condition including these words being imposed on a subsequent purchaser.

© 1999 Jack Mackinder

All Rights Reserved. No part of this publication may be reproduced or transmitted in any form or by any means, electronic or mechanical, including photocopy, recording or any other information storage and retrieval system, without the publisher's prior consent.

British Library Cataloguing-in-Publication Data
A catalogue record for this book is available from the British Library

ISBN 0-500-28094-0

Printed and bound in Slovenia

Contents

Preface

This work brings together, from various sources, some ideas about Celtic design and ornament that should be of use to a calligrapher wanting to create a work that is inspired by the Insular manuscripts but not merely a copy of an earlier work. The first thing to note is the distinction between design and ornament. I have taken design to mean the placing of squares, rectangles, circles, and other shapes in an arrangement that could be called a composition. Often the term Celtic design is used to describe the ornament that decorates a design, and the design is reduced to an accident, dictated by the size and shape of the ornament. I have tried to show how the ornament can be fitted to the design.

Producing an ornament to a predetermined size requires some calculations. If you normally skip over anything that looks like mathematics, don't. The arithmetic is quite simple : all that is required is to key a few numbers into a calculator.

The first part of the book describes the construction of six rectangles. Neither the names, which are not quite arbitrary, nor the constructions need be memorized: it is sufficient to recognize them and see how they are used when they are encountered in the section on page layouts.

Little will be gained by reading through the instructions: understanding is to be achieved with pencil and paper, by ruling up each of the designs and by trying each of the ornaments. For this you will need a sharp pencil, a T-square, a 45° and a 60° set square, a compass, an accurate ruler, and a lettering guide. The lettering guide is described on page 48. The title pages can be regarded as exercises in finding the key to a design, and for this reason, marks that would normally be erased have been left showing so that the construction can be readily discovered. Step by step constructions for the title pages and most of the layout pages are given at the end of the design section, on pages 31 to 46. You should refer to these pages only after attempting to rule up the design for yourself.

Celtic design

Design
elements

squares

Many page layouts in Insular manuscripts are derived from a square or a square divided into four. A square can be constructed to any specified size using only a compass and a straight edge.

Symmetric construction

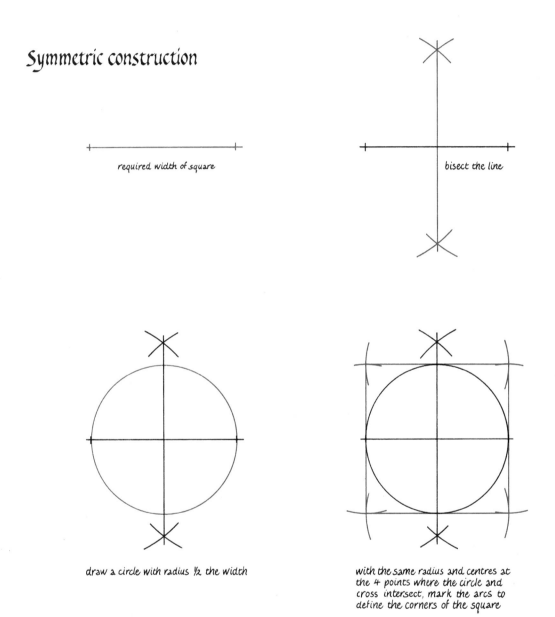

required width of square

bisect the line

draw a circle with radius ½ the width

with the same radius and centres at the 4 points where the circle and cross intersect, mark the arcs to define the corners of the square

Although the compass and straight edge methods are theoretically accurate, every small error is propagated throughout a design.

Asymmetric construction

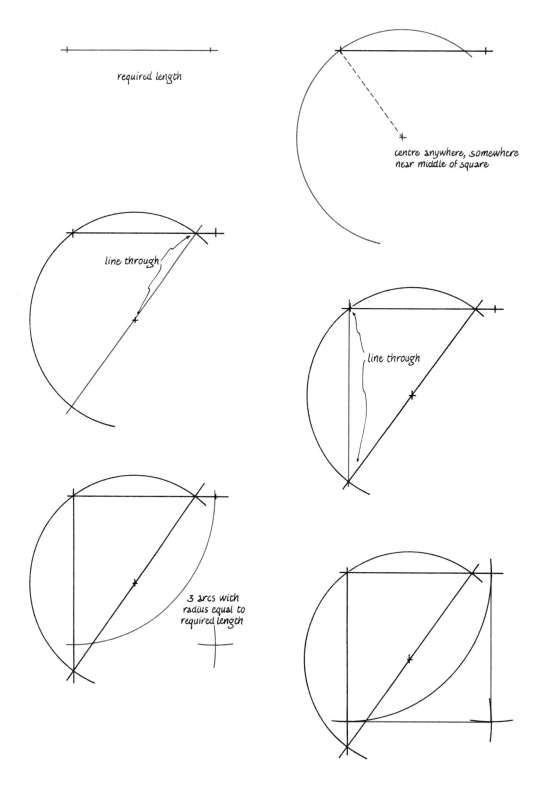

required length

centre anywhere, somewhere
near middle of square

line through

line through

3 arcs with
radius equal to
required length

10

An accurate construction using a T-square and a set square

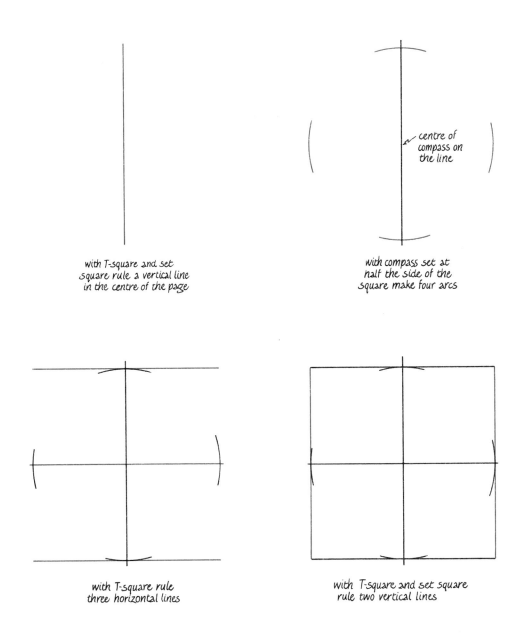

with T-square and set
square rule a vertical line
in the centre of the page

centre of
compass on
the line

with compass set at
half the side of the
square make four arcs

with T-square rule
three horizontal lines

with T-square and set square
rule two vertical lines

Not only is this construction simple and accurate but it also produces a square divided into four, which is the starting point for almost all the demonstrations of page layouts.

Rectangles

A study of the Insular manuscripts reveals that the page layouts can be created by following a procedure that generates precise, geometrically defined rectangles. These rectangles are derived from the diagonal of a square or of another rectangle and can be drawn quite simply with compass and straight edge. The ratio of the sides cannot be expressed as a whole number or a simple fraction. That is, the ratio of the sides is an irrational number.

In a few cases arithmetically defined rectangles occur; that is, they are formed by adding squares together. The ratio of the sides is a simple fraction, a rational number.

The value of precise proportions is described by Jan Tschichold:

> "It cannot be explained, but it is a fact areas of geometrically well-defined intentional proportions are more pleasing or more beautiful to man than those of arbitrary proportions."

In the demonstrations that follow, diagonals and arcs have been fully drawn for clarity. Only very short arcs are needed to define the corners of rectangles when drawing up a page design. The point of the compass is indicated with a ∘.

Robert Stevick published the method, as it is applied in the Book of Kells, in 1994.

√2 rectangle

The simplest rectangle generated from a square: the diagonal is projected onto a side.

Asymmetric construction

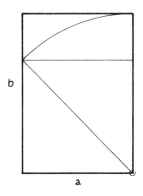

$$b = \sqrt{2}\,a \quad \text{or} \quad \frac{b}{a} = 1\cdot414\ldots$$

Symmetric construction

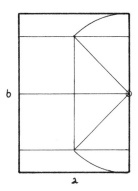

This rectangle has the shape of the ubiquitous sheet of A4 paper or any sheet of the A sizes. The √2 rectangle has the property that when cut in half, the half sheet has the same shape as the original.

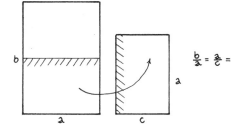

$$\frac{b}{a} = \frac{a}{c} = \sqrt{2}$$

√3 rectangle

Two diagonals are used to generate the √3 rectangle. First a half diagonal is projected onto a midline to form an intermediate rectangle and then the diagonal of this rectangle is projected onto the side of the square.

Asymmetric construction

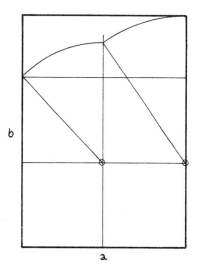

Symmetric construction

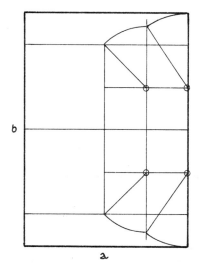

$$b = \frac{(1 + \sqrt{3})a}{2} \quad or \quad \frac{b}{a} = 1.366...$$

Durrow rectangle

A rectangle that can be found in the Book of Durrow is formed by using the side of a square to define the diagonal of the rectangle. Set a compass to the length of the side of the square and then, with the centre of compass at the centre of the square, mark arcs on the extended sides.

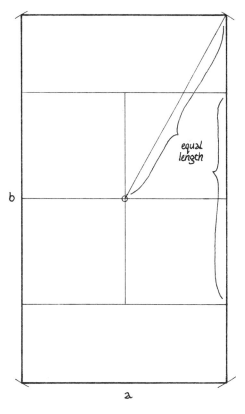

equal length

$$b = \sqrt{3}\,a \quad \text{or} \quad \frac{b}{a} = 1.732\ldots$$

The rectangle can be formed by joining two 60° triangles. Plato, in the *Timaeus*, described this triangle as "the most beautiful of all the many figures of triangles".

60°

√5 rectangle

Professor Stevick has used this rectangle to describe constructions of portrait pages from the Book of Kells and the St Gall Gospels. It is more complex than the preceding ones and its shape is only very slightly different from a √5 rectangle. The method partly resembles the construction of a golden rectangle.

Asymmetric construction

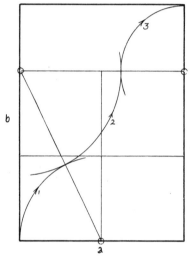

$$b = \frac{(5-\sqrt{5})a}{2} \quad or \quad \frac{b}{a} = 1.381...$$

Symmetric construction

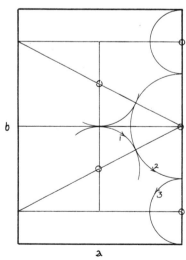

Golden rectangle

The construction of a golden section was known to Euclid about 300 B.C.E. (book 2, proposition 11) but only occasionally occurs within the design of Insular manuscripts. Luca Paciolo described the aesthetic importance of the golden section in *De Divina Proportione*, published in Venice, 1509.

Asymmetric construction

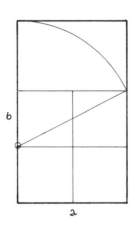

$$b = \frac{(1 + \sqrt{5})a}{2} \quad or \quad \frac{b}{a} = 1.618\ldots$$

Symmetric construction

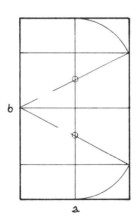

The golden rectangle has the property that if the square on the shorter side is removed, a golden rectangle remains.

Arithmetic rectangles are formed by adding squares together. These can be constructed simply, by ruling two lines at right angles, marking off the length of the sides with dividers, and then ruling up with T-square and set square.

3×2

$$b = \frac{3a}{2} \quad or \quad \frac{b}{a} = 1.5$$

4×3

$$b = \frac{4a}{3} \quad or \quad \frac{b}{a} = 1.333...$$

Comparison of rectangles

To determine which rectangle has been used in a manuscript measure the sides, divide the longer side by the shorter, and compare the ratio with the ones given here. Several measurements should be made because of the distortion that may have occurred in the reproduction or, over the years, to the vellum. A more convenient method uses proportional dividers. Set the dividers to fit a known rectangle and then check to see if the manuscript rectangle is in the same proportion.

Page
×
layout

The method for constructing a layout

- Begin with a square. This initial square is indicated in the demonstrations by a □ at each corner.

- Extend the square to a rectangle using one of the methods set out on pages 13 to 18.

- Define the widths of borders, the length of panels, the centres and radii of circles by looking for intersections of construction lines or by creating intersections by drawing diagonals or by projecting lines.

Demonstrations
The next 9 pages show how the rectangle can generate a page layout. It should not be assumed that the correctness of any of the constructions has been proved. The modern calligrapher need only understand the method to be able to produce new works, not merely copies, in the style of Insular, 7th to 9th century manuscripts. In the first example, from the Book of Durrow, all the elements fall into place most convincingly. The other examples are from the Book of Kells because reproductions with which to compare the constructions are readily available. For the Durrow example the construction sequence is set out in detail. The sequence for the other pages will become clear as the page is drawn up.

Book of Durrow f1v

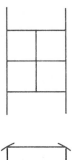

Draw a square with sides 123 mm[*], divide the square into four, extend the vertical sides;

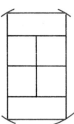

with radius equal to the side, and centre at the centre of the square, scribe four arcs to form a Durrow rectangle;

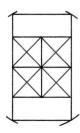

draw the diagonals for all the squares;

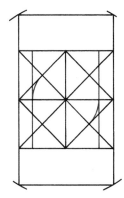

project the half diagonals of the small squares onto the middle horizontal line and then draw vertical lines to form an inner rectangle (a $\sqrt{2}$ rectangle);

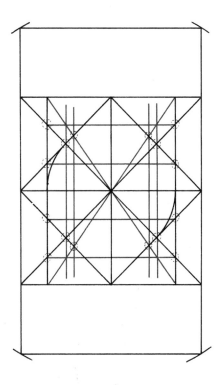

draw the diagonals for the inner rectangle, draw the vertical lines and one side of the horizontal arms of the double arm cross using the points of intersection shown as ○;

★ *See the bibliography on page 95 for a reproduction to compare with this construction.*

complete the arms and centre band, making them the same width as the two vertical bands, and then add about ·7 ($\frac{\sqrt{2}}{2}$) of that width to each side of the little squares formed where the bands cross.

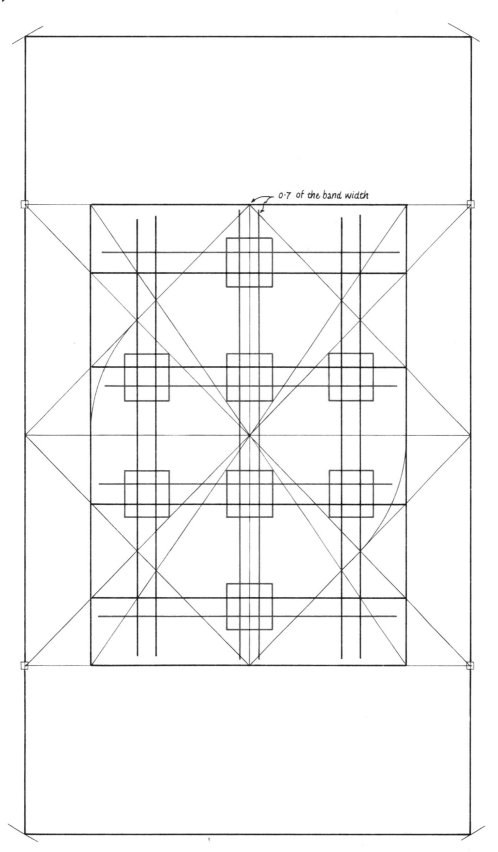

0·7 of the band width

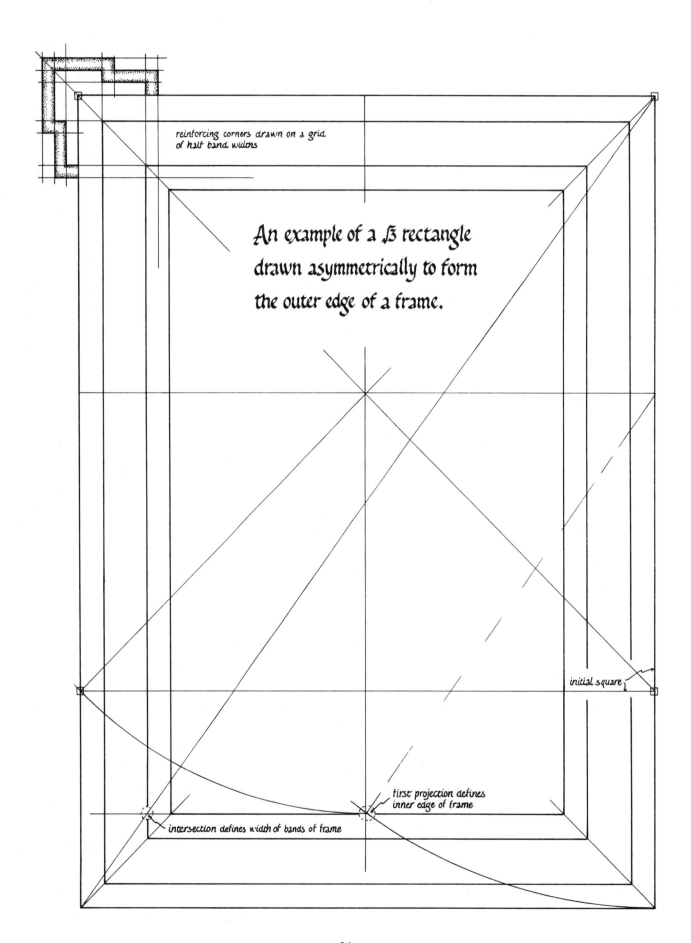

reinforcing corners drawn on a grid
of half band widths

An example of a √3 rectangle
drawn asymmetrically to form
the outer edge of a frame.

initial square

first projection defines
inner edge of frame

intersection defines width of bands of frame

Book of Kells f27v

Start with a √3 rectangle, symmetrically drawn, for the inner edge of the frame.
Only one diagonal needs to be drawn to define the size of the border.

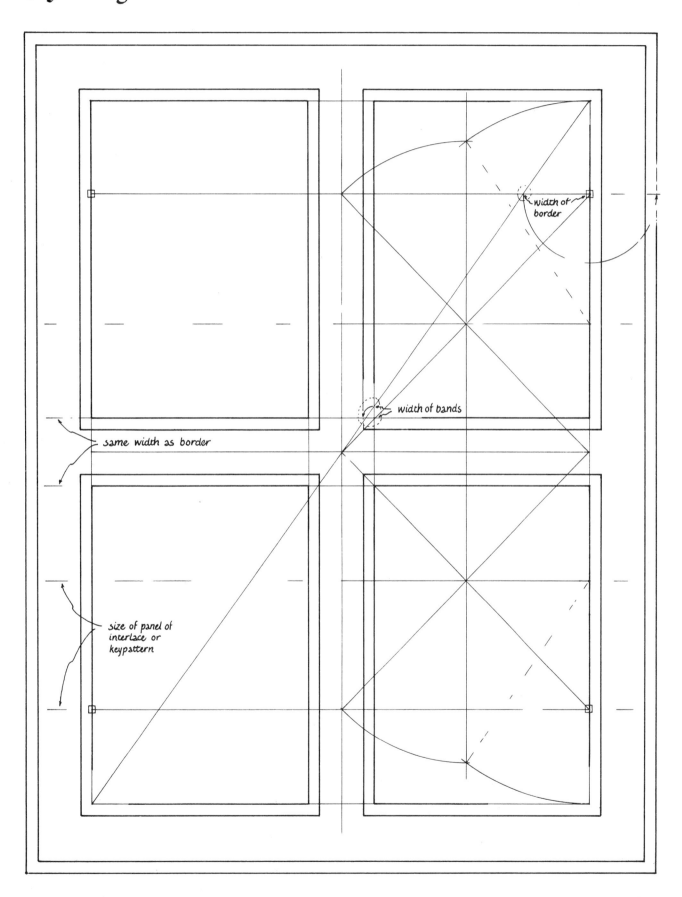

width of border

width of bands

same width as border

size of panel of
interlace or
keypattern

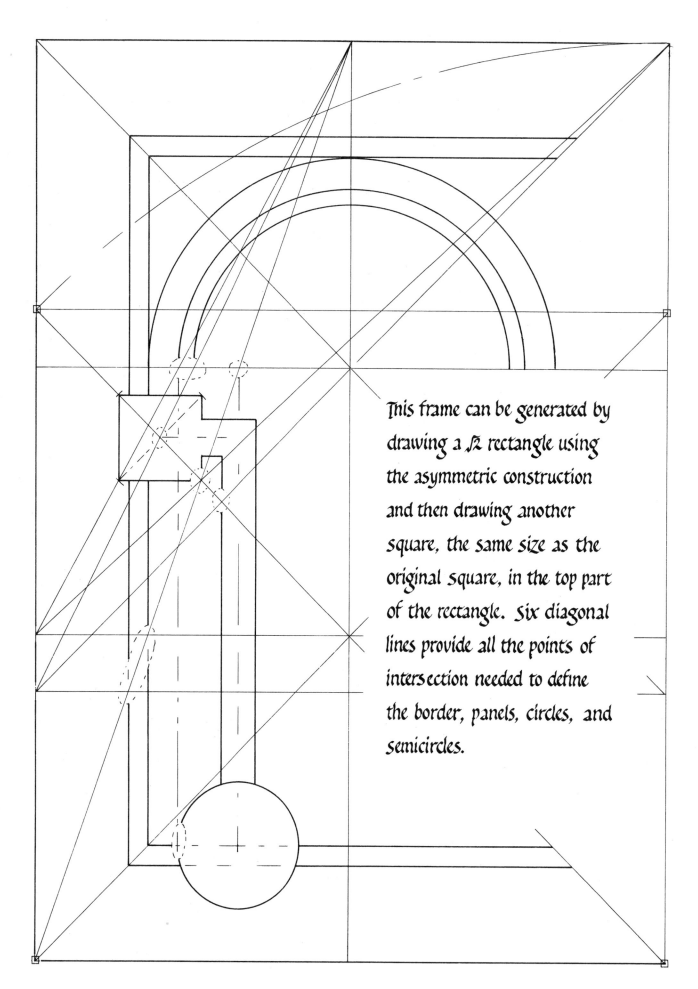

This frame can be generated by drawing a √2 rectangle using the asymmetric construction and then drawing another square, the same size as the original square, in the top part of the rectangle. Six diagonal lines provide all the points of intersection needed to define the border, panels, circles, and semicircles.

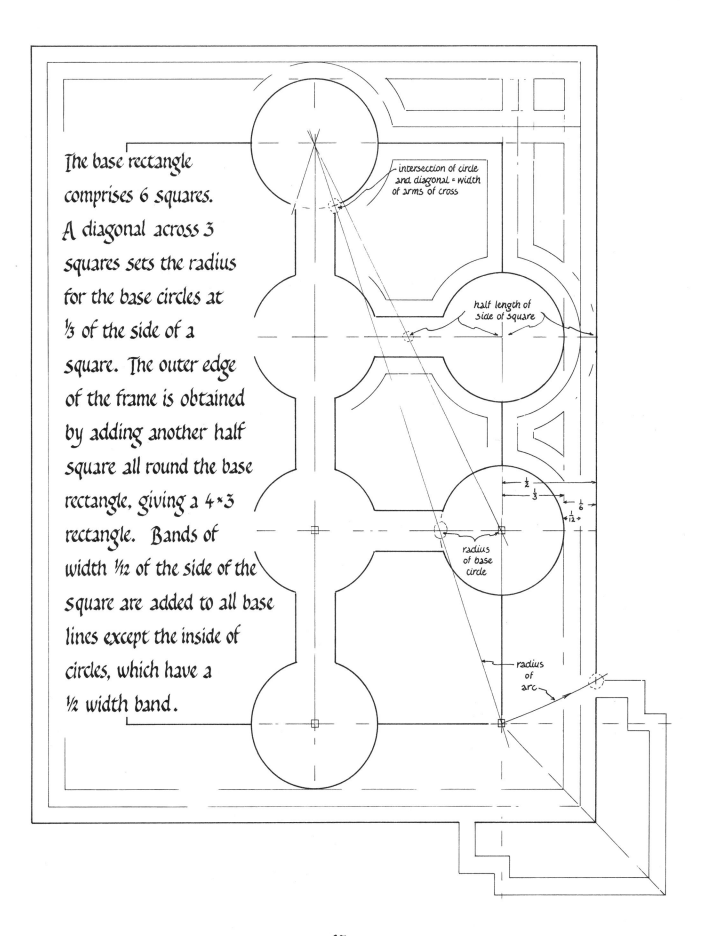

The base rectangle comprises 6 squares. A diagonal across 3 squares sets the radius for the base circles at ⅓ of the side of a square. The outer edge of the frame is obtained by adding another half square all round the base rectangle, giving a 4×3 rectangle. Bands of width ½ of the side of the square are added to all base lines except the inside of circles, which have a ½ width band.

intersection of circle and diagonal = width of arms of cross

half length of side of square

radius of base circle

radius of arc

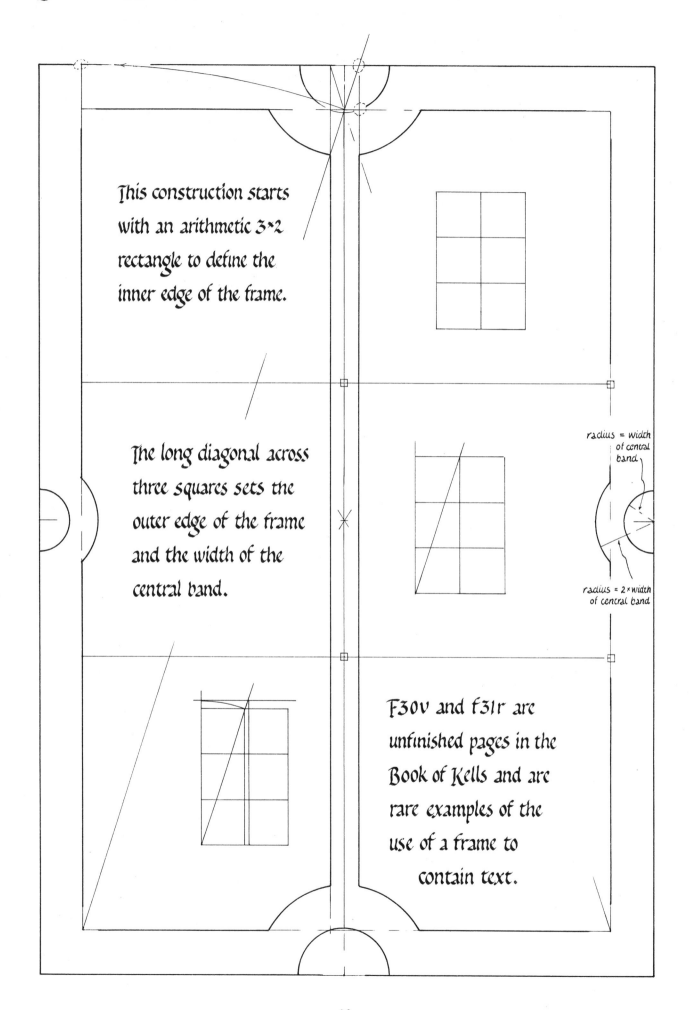

This construction starts with an arithmetic 3×2 rectangle to define the inner edge of the frame.

The long diagonal across three squares sets the outer edge of the frame and the width of the central band.

radius = width of central band

radius = 2×width of central band

F30v and f31r are unfinished pages in the Book of Kells and are rare examples of the use of a frame to contain text.

Book of Kells f34r

The famous chi-rho page may seem an unlikely candidate for a formal rectangular construction but an underlying symmetrically drawn $\sqrt{2}$ rectangle can be found.

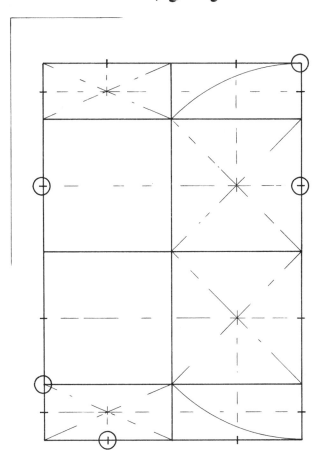

After drawing the rectangle find the midpoints, around the outer edge, of the component squares and rectangles. The centres of some circles are at midpoints, shown with a \bigcirc.

The pairs of diagonals (1,2), (3,4), (5,6), (7,8) define the centres of circles; (9,10) defines the midpoint of the lozenge at the intersection of the two strokes of the X and diagonal 11 sets its orientation. The diagonals 12,13,9,14 define the corners of the L-shaped panel.

The construction may not be entirely convincing; it could be argued that if sufficiently many diagonals are drawn inevitably some of them will intersect at the centre of a circle. Perhaps the construction can be understood as a simple, accurate method for transferring a small-scale draft design to a full-scale finished version using only a compass and a straight edge. The design can be scaled up to any required size by altering the size of the initial square.

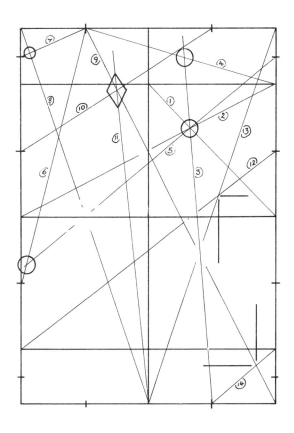

Book of Kells f34r

All the elements match to within 4 mm when the construction is ruled up to fit a full sized reproduction. Perhaps the ancient scribe's final draft shifted slightly as he traced the design onto the page.

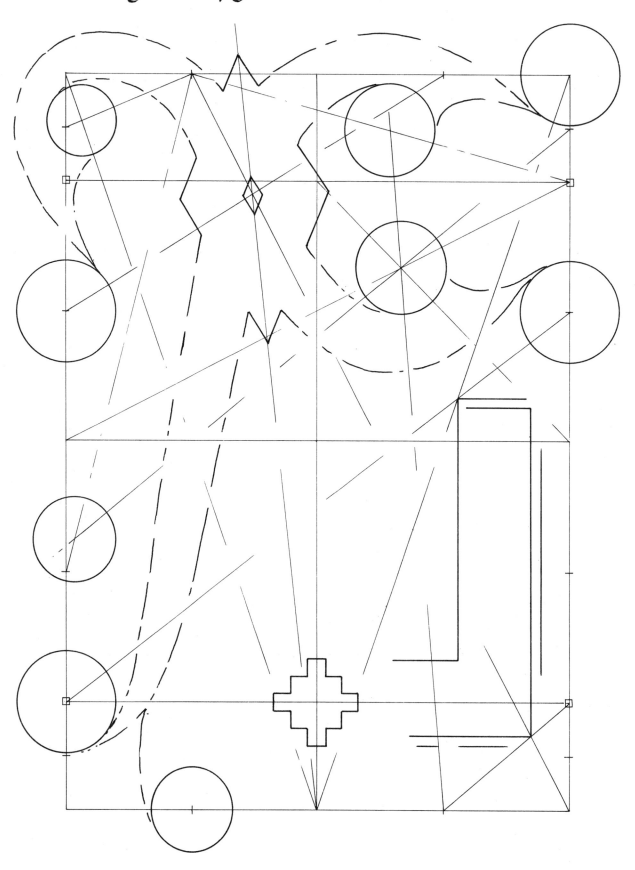

Keys to the design pages

Key for page 7

Compare with Kells f32v and contrast with the construction on page 26, Kells f28v.

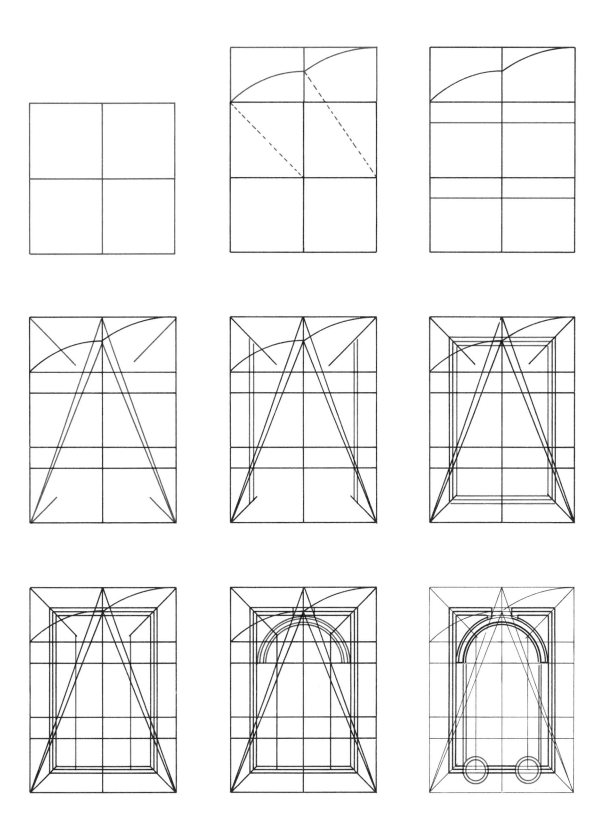

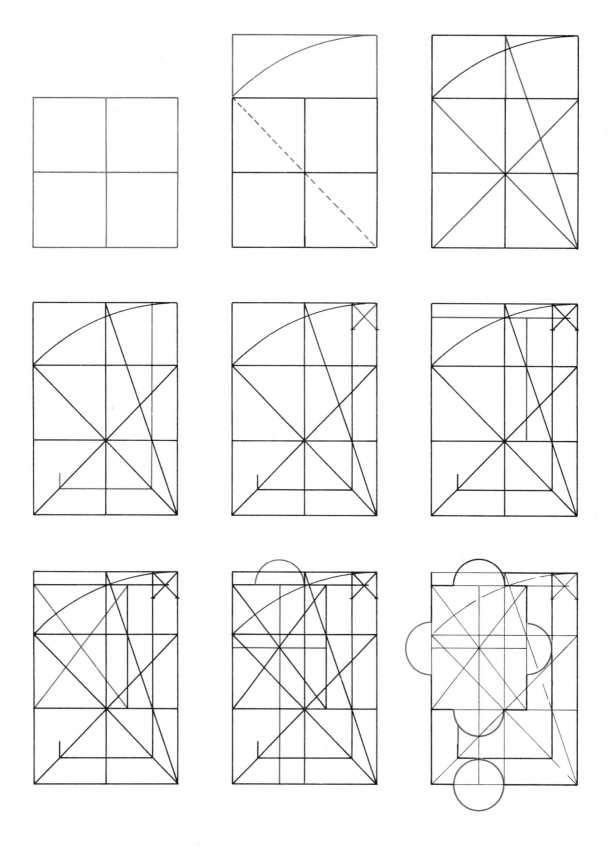

Key for page 20

Compare with Kells f291v.

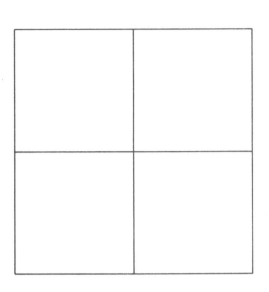

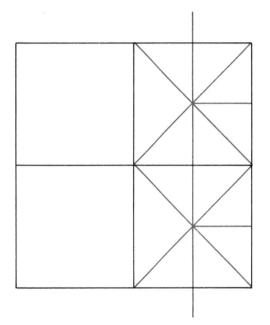

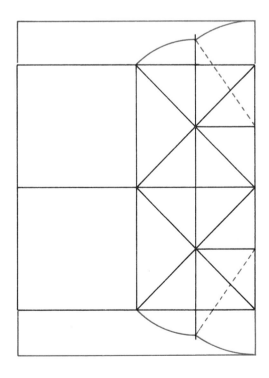

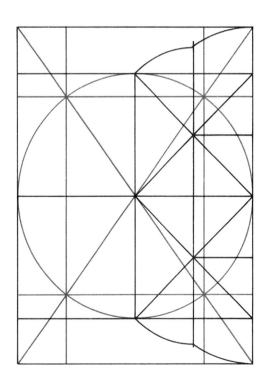

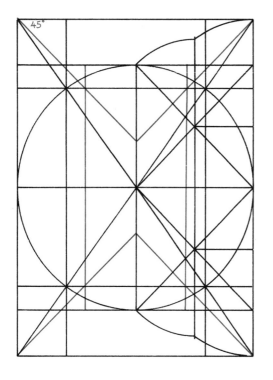

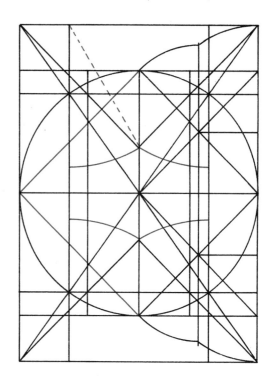

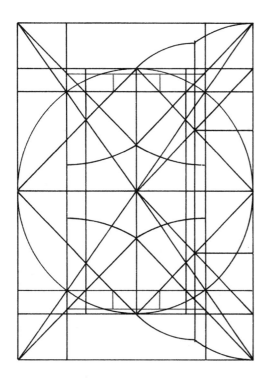

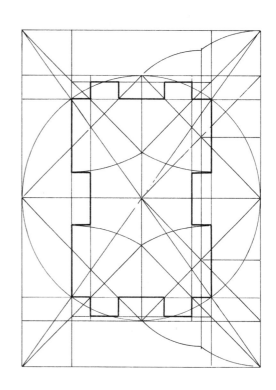

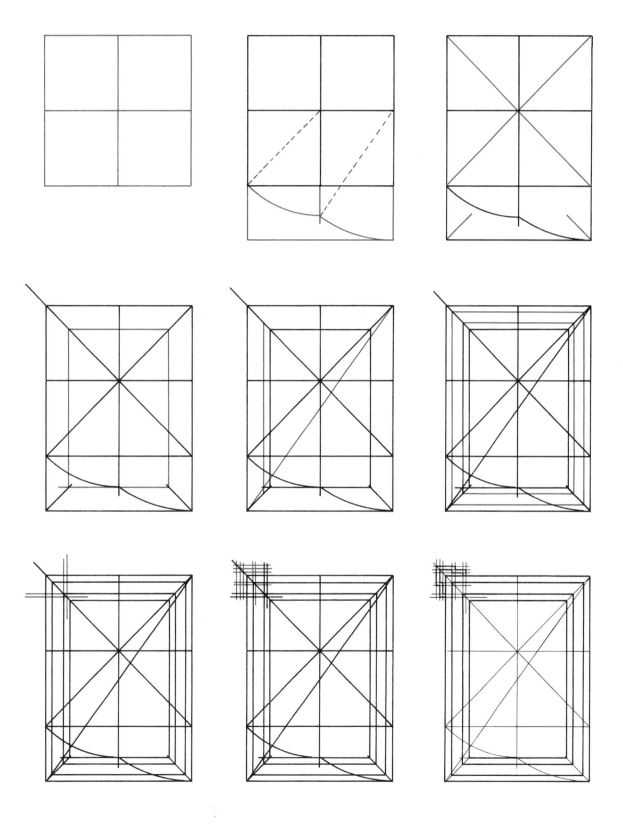

Key for page 25

Book of Kells f27v

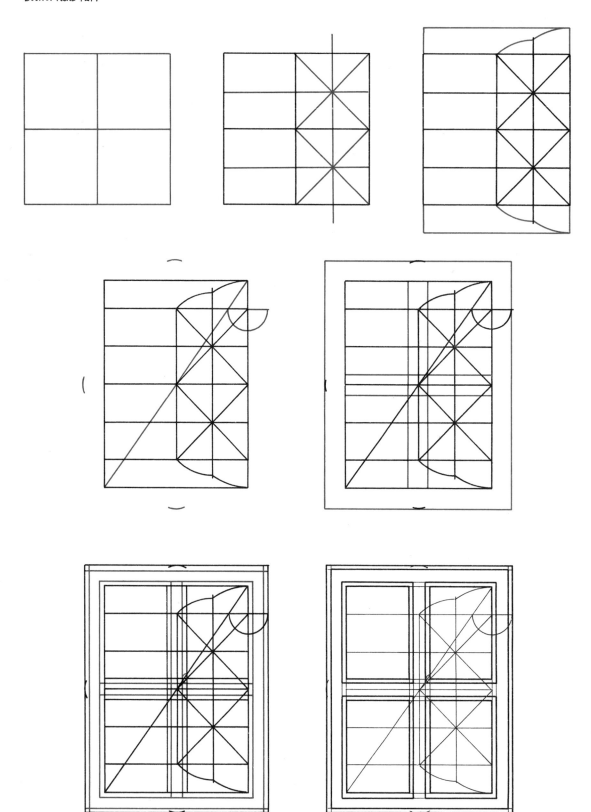

Key for page 26

Book of Kells f28v, contrast with page 7, Kells f32v

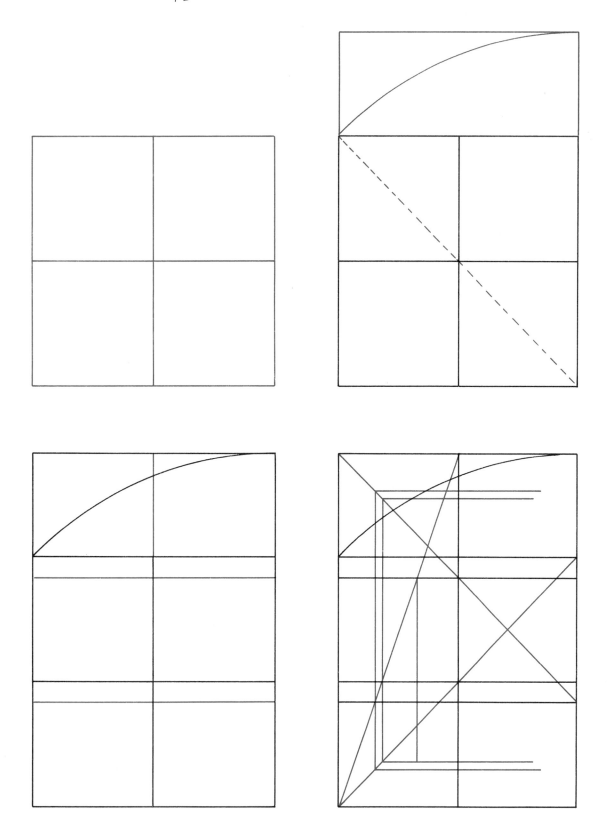

37

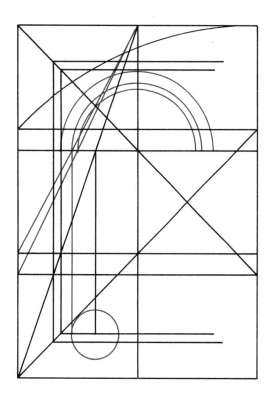

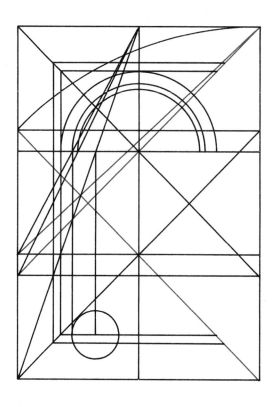

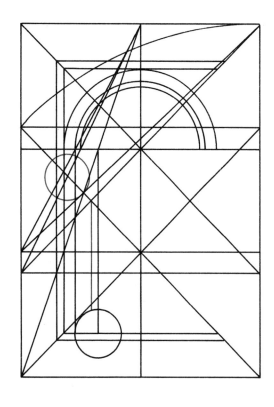

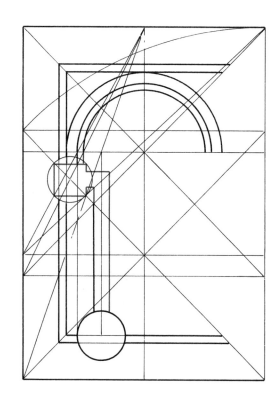

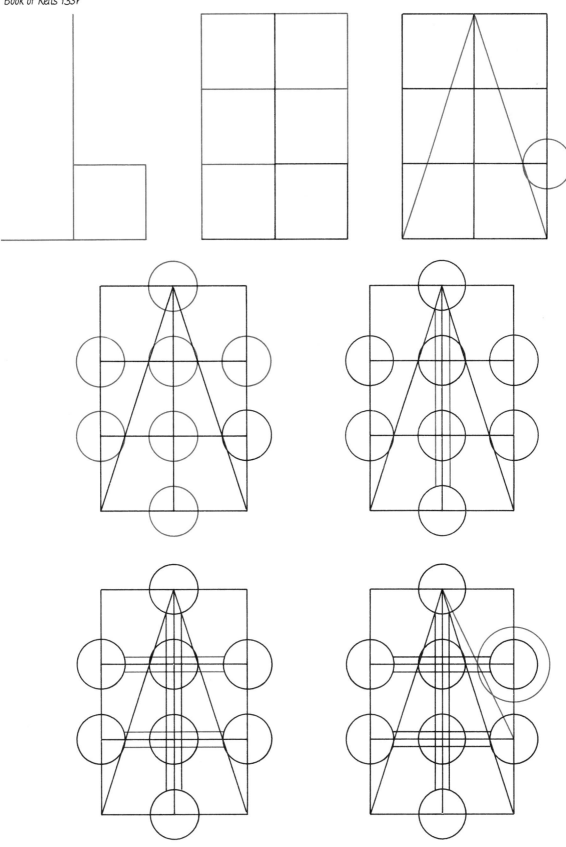

Key for page 27 – part 2

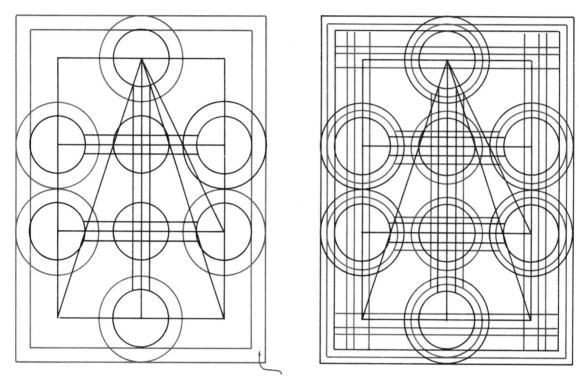

set half the width of this band on dividers and mark the half width almost everywhere

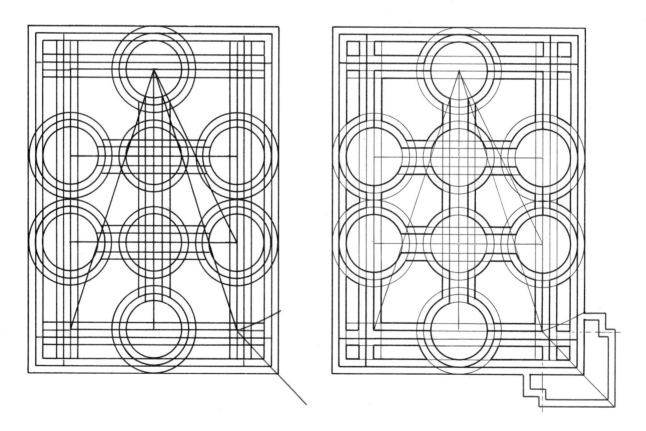

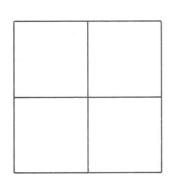

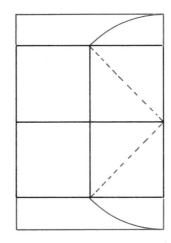

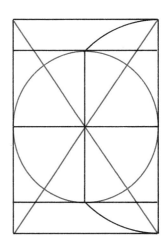

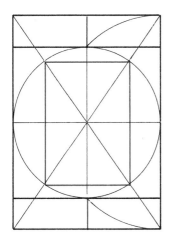

Break line pattern for the tulip shaped interlace

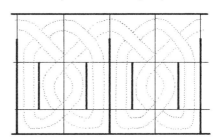

42

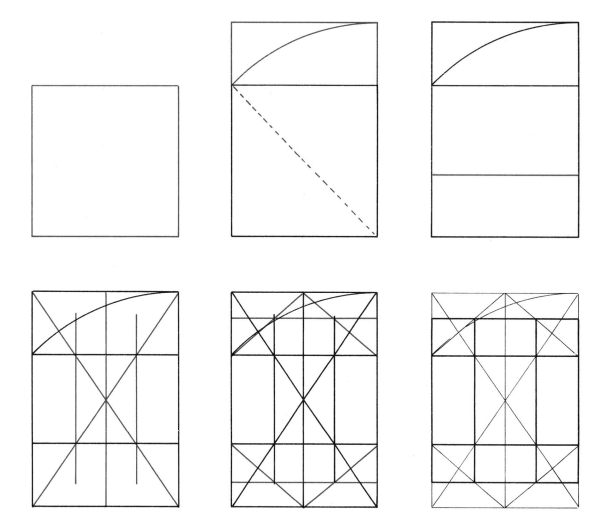

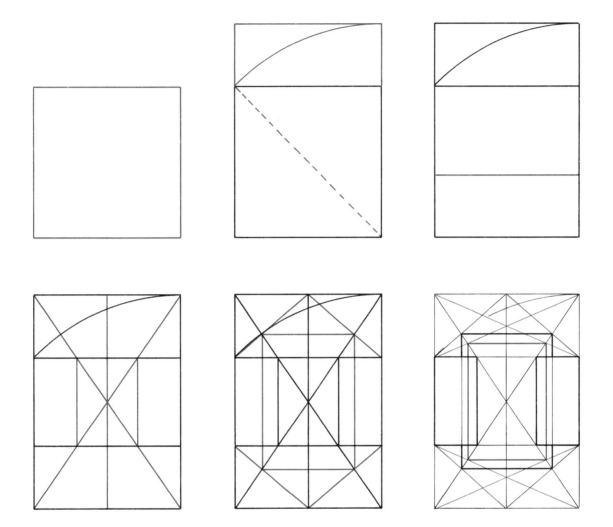

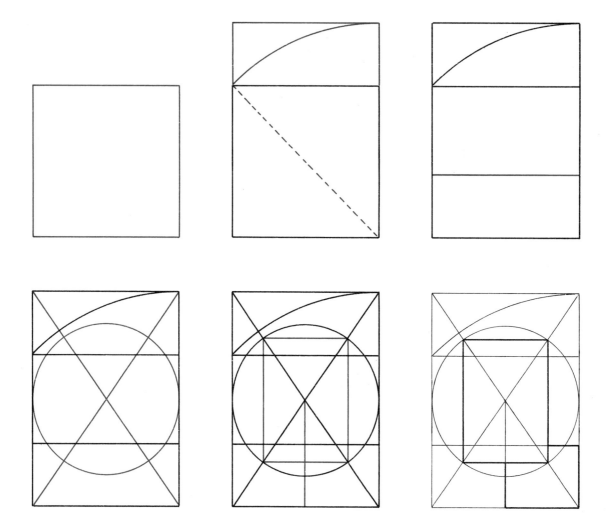

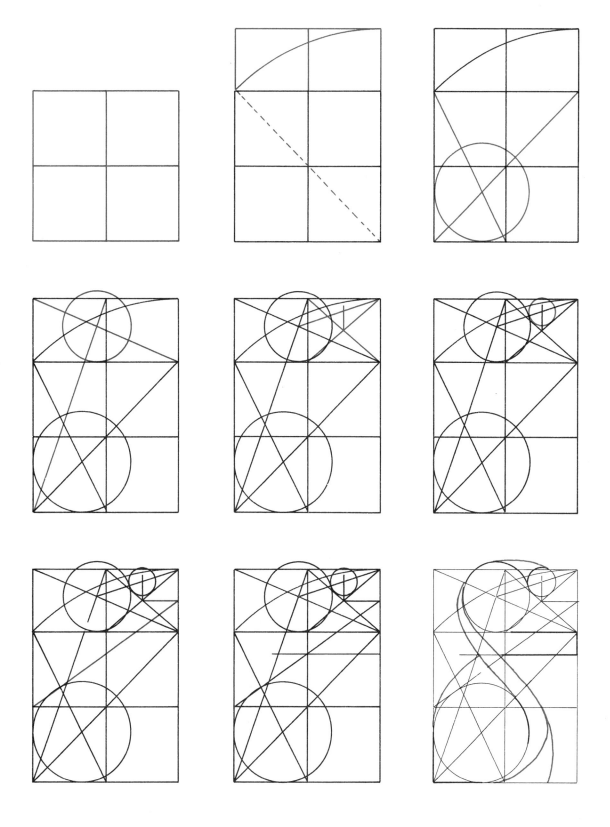

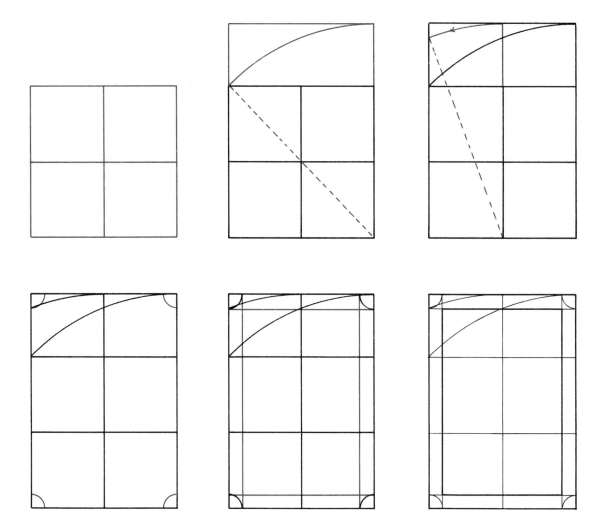

Celtic
ornament

*

A note on ruling grids

All the ornamental patterns on the following pages require as a first step the ruling up of a very accurate grid. Graph paper is too rigid to be of any use since the sizes are fixed and the grid exactly square. An ideal device for ruling a grid is the Ames lettering guide.

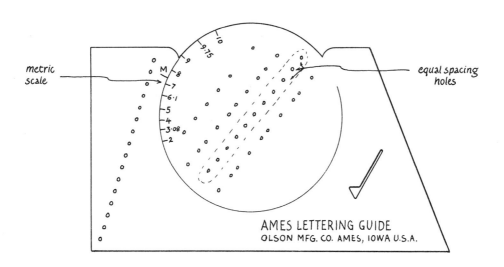

metric scale

equal spacing holes

AMES LETTERING GUIDE
OLSON MFG. CO. AMES, IOWA U.S.A.

To set the guide to a required ruling:

Rough setting

1. multiply the spacing in millimetres by 2·5 and set this on the metric scale,

Fine setting

2. rule a line with the top and bottom hole of the equal spacing holes,

3. measure the distance between the lines as accurately as you can and divide by 10,

4. if this is not the spacing required, adjust the lettering guide and repeat steps 2 and 3 until the correct spacing is achieved.

For example, to rule lines 1·76 mm apart

$$\text{rough setting} = 1.76 \times 2.5$$
$$= 4.4$$

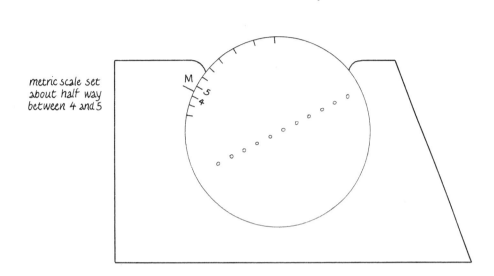

metric scale set
about half way
between 4 and 5

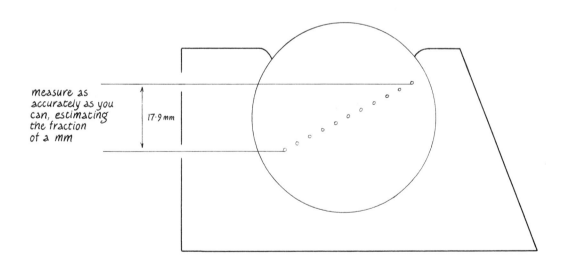

measure as
accurately as you
can, estimating
the fraction
of a mm

17·9 mm

$$\text{distance between lines} = 17.9 \text{ mm}$$
$$\text{divide by 10} = 17.9 \div 10$$
$$= 1.79 \text{ mm}$$

the spacing is too wide: turn guide disc down (clockwise) slightly and try again

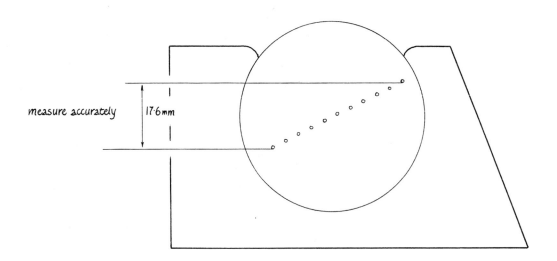

distance between lines = 17·6 mm

divide by 10 = 17·6 ÷ 10

 = 1·76 mm, as required

Step
patterns

step patterns

are the simplest of the Celtic ornaments. A 3×3 square or a 4×4 square are units often used for building up a pattern. It is a good idea to rule up and cut out several, at least 8, of the units for manipulating into patterns.

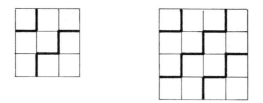

When they occur in Insular manuscripts the units are usually arranged to produce a cross.

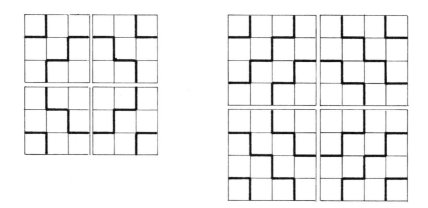

By setting four units together and then systematically rotating the units, 256 patterns can be generated. Not all these patterns are distinct; many are too asymmetric to be of any use; only a few look like Celtic work but a modern work could go —

beyond the Celtic style.

Patterns that stay within the Celtic tradition are the two shown on the previous page and

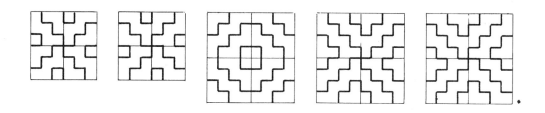

.

The Durham Cassiodorus has on f172v*a pattern for which the unit is ⊞ . At least one central band needs to be expanded to make the pattern work.

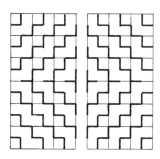

One of the patterns has the central band offset. Does it look nicely asymmetric or does it look like a mistake?

★ See the bibliography on page 95 for a reproduction of the Durham Cassiodorus f172v.

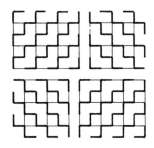 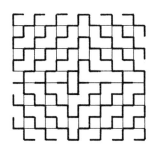

Fitting a pattern to a square or a rectangle made from squares is a simple matter. Measure the side of the square and divide by the number of times the pattern repeats. Then divide by the number of squares in the pattern and rule up a grid of this size. For all other designed shapes it is best to use the shape as a window on the pattern.

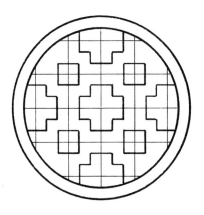

Ideas for creating step patterns with diagonal or curved lines are to be found in reproductions of pages from the Book of Durrow and the Lindisfarne Gospels.

Key
patterns

Key patterns

Key patterns get their name from the resemblance to the perforations in a key, which allow the key to pass the wards of a lock. They can be drawn on a square grid but, unlike step patterns, they do not fit together perfectly.

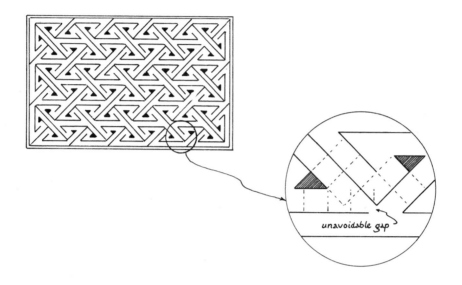

unavoidable gap

The enlargement shows that if the paths are made of uniform width then some lines do not join. Obviously the diagonal of a square cannot be the same length as the side. The imperfection is usually hidden by the thickness of the lines or an inaccuracy of the drawing.

A simple key pattern for a border or a panel can be drawn on graph paper using a method published by Iain Bain in 1993. Begin by drawing diagonals across five squares.

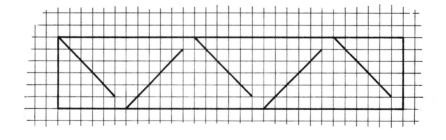

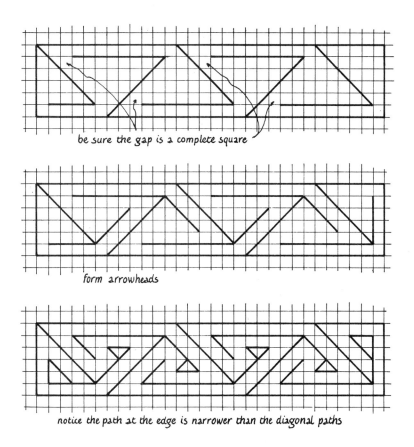

be sure the gap is a complete square

form arrowheads

notice the path at the edge is narrower than the diagonal paths

To fit the pattern to a panel that has occurred naturally in a design, measure the width of the panel and its length. Then

r is the number of times the pattern can be repeated	r =	length ÷ width rounded to a whole number
grid across the width	=	width ÷ 6·83
grid along the length	=	length ÷ (6 × r + 0·83)

For example, for the inner panel on page 55

width	=	12 mm
length	=	103 mm
r	=	103 ÷ 12 rounded
	=	8 (or 9 to compress the pattern)
grid across the width	=	12 ÷ 6·83
	=	1·76 mm

$$\text{grid along the length} \quad = \quad 103 \div (6 \times 8 + 0.83)$$
$$= \quad 103 \div 48.83$$
$$= \quad 2.11 \ mm$$

12 mm × 103 mm panel —

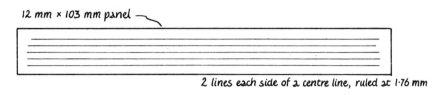

2 lines each side of a centre line, ruled at 1.76 mm

The grid lines are centred in the panel so that the slightly larger paths at the edge are equal.

23 lines each side of a centre line, ruled at 2.11 mm

To fill a panel with

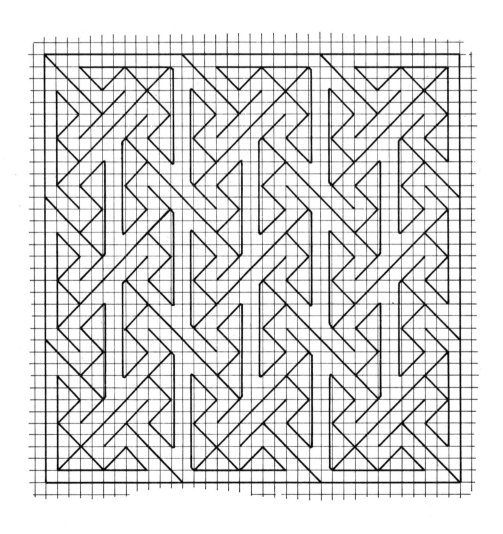

first decide how many times the pattern can be repeated each way to best fill the space and then calculate the grid size to exactly fill the space.

r_w is the number of times the pattern can be repeated across the width

r_l is the number of times the pattern can be repeated along the length

grid across the width $=$ width $\div (12 \times r_w + 0.83)$

grid along the length $=$ length $\div (12 \times r_l + 0.83)$

For example, for the pattern on page 55

width $=$ 40 mm

length $=$ 103 mm

Find the number of times the pattern is to be repeated.

With $r_w = 1$ width of repeating pattern $=$ 40 mm

r_l $=$ 103 ÷ 40

$=$ 2 with remainder 23 mm

With $r_w = 2$ width of repeating pattern $=$ 40 ÷ 2

$=$ 20 mm

r_l $=$ 103 ÷ 20

$=$ 5 with remainder 3 mm

With $r_w = 3$ width of repeating pattern $=$ 40 ÷ 3

$=$ 13⅓ mm

r_l $=$ 103 ÷ 13⅓

$=$ 7 with remainder 9⅔ mm

Thus the 2 × 5 arrangement gives the best fit.

grid across the width $=$ width $\div (12 \times r_w + 0.83)$

$=$ 40 ÷ (12 × 2 + 0.83)

$=$ 40 ÷ 24.83

$=$ 1.61 mm

59

$$\text{grid along the length} = \text{length} \div (12 \times r_l + 0.83)$$
$$= 103 \div (12 \times 5 + 0.83)$$
$$= 103 \div 60.83$$
$$= 1.69 \text{ mm}$$

40 mm × 103 mm panel

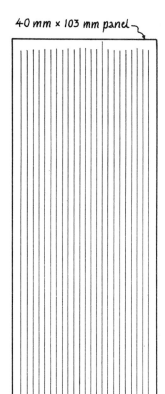

11 lines each side of a
centre line, ruled at 1.61 mm

29 lines each side of a
centre line, ruled at 1.69 mm

Any key pattern that has been drawn up on graph paper can be fitted to a rectangular panel using the formulas

s_w is the number of squares
across the pattern

s_l is the number of squares
along the pattern

$$\text{grid across the width} = \text{width} \div (s_w + 0.83)$$

$$\text{grid along the length} = \text{length} \div (s_l + 0.83)$$

The correction for the edge path, 0.83, is $(2\sqrt{2} - 2)$ and is valid only if the grid is close to square.

The decoration Romilly Allen calls tree key-pattern is easily drawn. The main stems zig-zag like a divaricating shrub, across 3 or 4 squares for each line. Branches are added at each node across squares 2-2-1-1 for a 3-square stem or 3-3-2-2-1-1 for a 4-square stem.

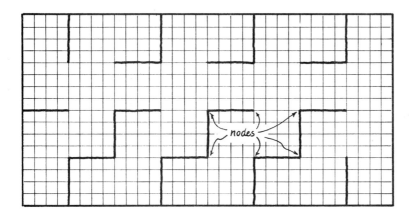

Let the stems grow, 4 squares at a time, to no more than half way across the panel.

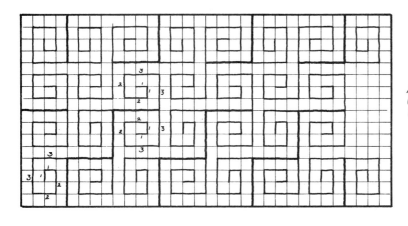

At each node add a 3-3-2-2-1-1 branch; add two branches at the end of a stem.

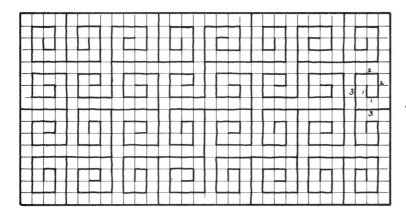

Fill any gaps with branches growing out from the ground.

Tree key-pattern can also be drawn diagonally, with the stems growing out from a ground of triangular mounds. With 3-square stems and 2-2-1-1 branches the basic pattern is

 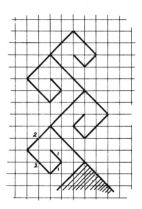

The grid size to fit the pattern to a panel is the width and the length of the panel divided by 6 (by 8 for 4-square stems) and then divided by the number of triangles at the edge of the pattern.

As an example, consider the panel

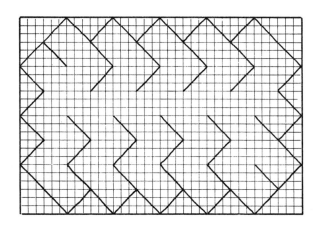

To produce a balanced pattern do not let the stems grow past the midline.

width	=	52 mm
length	=	78 mm
grid across the width	=	52 ÷ 6 ÷ 4 = 2·17 mm
grid along the length	=	78 ÷ 6 ÷ 6 = 2·17 mm

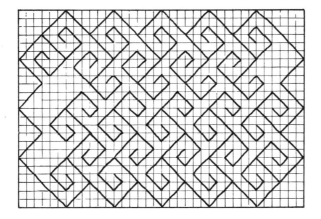

Be sure to add branches only to main stems. Do not add branches to branches.

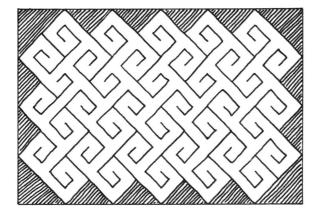

Finish by filling in blanks with 2-2-1-1 branches growing from the ground.

A border pattern can be made from a single main stem on an eleven square grid.

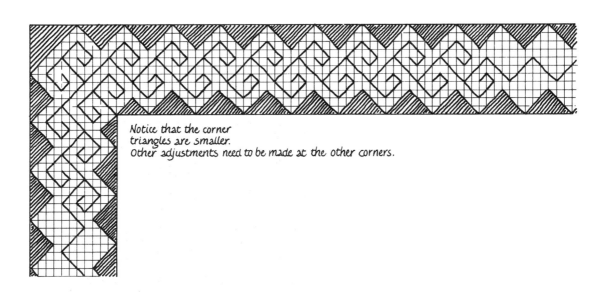

Notice that the corner triangles are smaller.
Other adjustments need to be made at the other corners.

Interlace

Interlace

is the pattern most commonly identified as Celtic ornament. Several methods for drawing it have been published. A method using rows of dots, called 'the secret method' by Aidan Meehan, is claimed to be the method used by the ancient scribes. Although it is interesting to speculate on how the ancient scribes worked, a better method for the modern designer was invented by Andy Sloss and published in 1995.

An understanding of knotwork begins with an analysis of simple plaits.

two strand

2 strands cross once

three strand

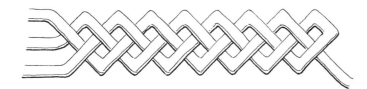

3 strands cross twice
an odd number of strands leaves a loose
end that can be woven into another pattern

four strand

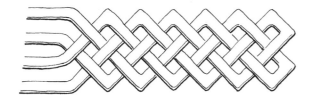

4 strands cross 3 times

In the Book of Kells 4 and 6 strand interlace are most commonly used.

A rectangular panel can be filled with plaitwork using a grid of squares, where every square contains two strands .

All the interlace in this work is right-handed, i.e. the strand from top-left to bottom-right is on top and is drawn first ◻, and then ◻.
The boundaries are drawn with a pair of sides on the grid and a pair of sides between the grid lines.

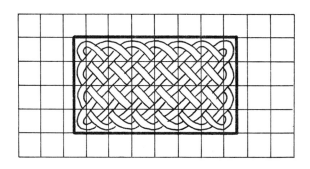

Knots are formed in the plait by introducing break lines.

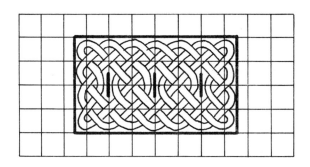

The method step by step

1. Rule up a grid within the required frame, making sure that half squares occur at one pair of opposite sides.

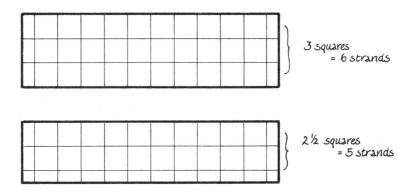

3 squares
= 6 strands

2½ squares
= 5 strands

2. Add break lines to make a knot pattern. Break lines should be —
 EITHER on a grid line and end half way between the grid lines

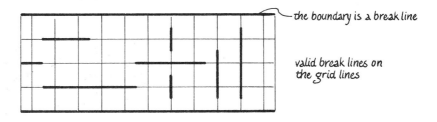

the boundary is a break line

valid break lines on the grid lines

OR between the grid lines and end on a grid line.

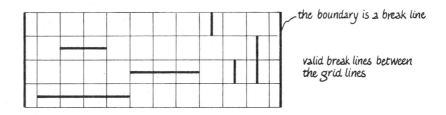

the boundary is a break line

valid break lines between the grid lines

Where two break lines meet or cross, one should be on the grid and the other between the grid.

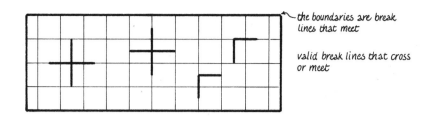

the boundaries are break lines that meet

valid break lines that cross or meet

To produce patterns in a Celtic style the break lines should be placed in a reasonably regular fashion. Some knots described by Romily Allen:~

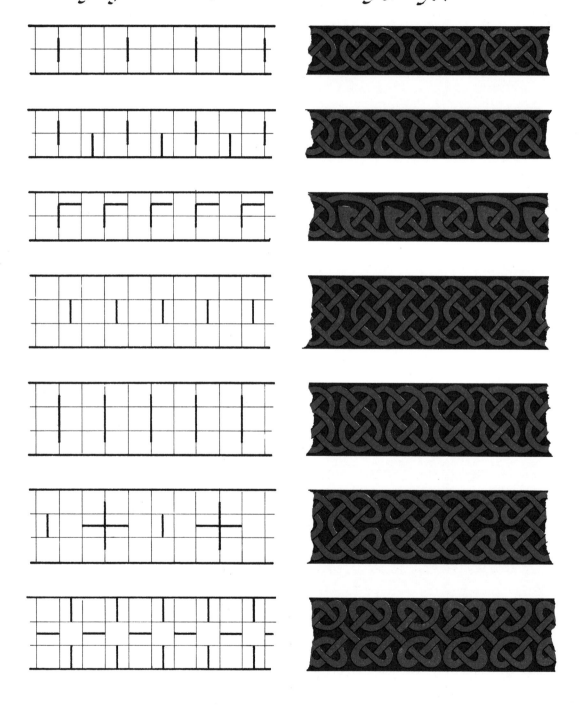

3. Draw all the top-left to bottom-right strands. The strands enter diagonally, cross the square diagonally, and exit diagonally unless blocked by a break line.

Break lines prevent a diagonal exit.

Break lines prevent the strand crossing the square.

Break lines prevent a diagonal entry.

Do not try to remember all the combinations — there are 27 of them.

Remember the rule: start at top-left, enter, cross and exit diagonally unless blocked by a break line.

For example —

Step 1. Rule a grid.

Step 2. Add break lines.

Step 3.

Every complete square should now contain one strand. At this stage do not let any part of the strand cross a grid line. The half squares at a pair of opposite edges can be left for the next step.

69

4. Draw a second strand in each square, noticing that it crosses the intersection of grid lines

and links up the strands.

5. Fill in the background, carefully observing the shapes of the negative space. ⌒ ◆ ● ↤ ⟩

———————————— ◪ ————————————

To analyse a pattern so that it can be copied:

1. count the number of times the strands cross from one side of the pattern to the other;

2. then the number of squares required is

number of squares = (crossings + 1) ÷ 2
e.g. = (7 + 1) ÷ 2
= 4.

3. Decide where the break lines occur, using the rules at step 2 on page 67.

The method works when the grid is not square. The basic unit is:

Thus any number of shapes can be filled with interlace.

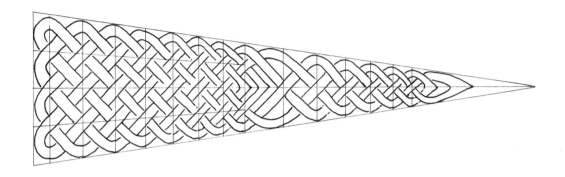

Sometimes double strands are used.

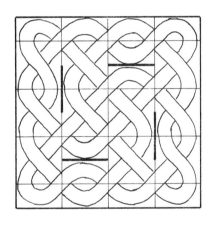 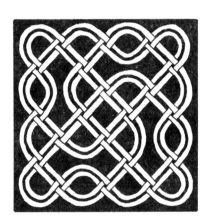

If the two strands are close together they can be formed by drawing a centre line throughout and then drawing a swastika at each intersection.

If the strands are to be further apart draw a thickened centre line, being careful to leave each intersection blank. Place a square at the centre of each intersection and then outline the strands.

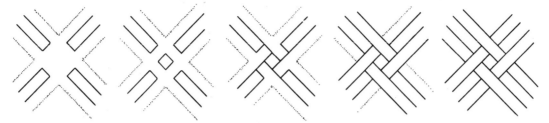

Double stranded patterns can be drawn using the method for single strands by doubling the number of squares in the grid. Where the strands run parallel to the break lines extra break lines are required to split the strands. Where the strands are diagonal the increased number of squares will split the strands.

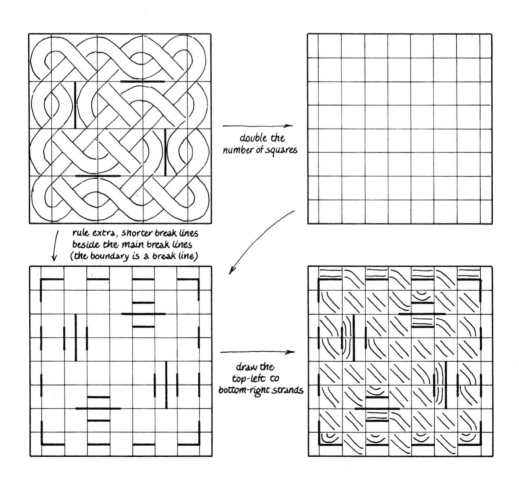

double the number of squares

rule extra, shorter break lines beside the main break lines (the boundary is a break line)

draw the top-left to bottom-right strands

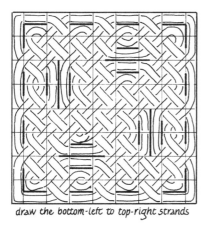

draw the bottom-left to top-right strands

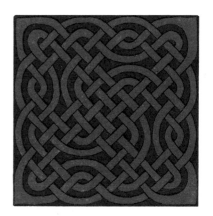

Interlace can be drawn freehand to fill an irregular shape, or to fill a triangle.

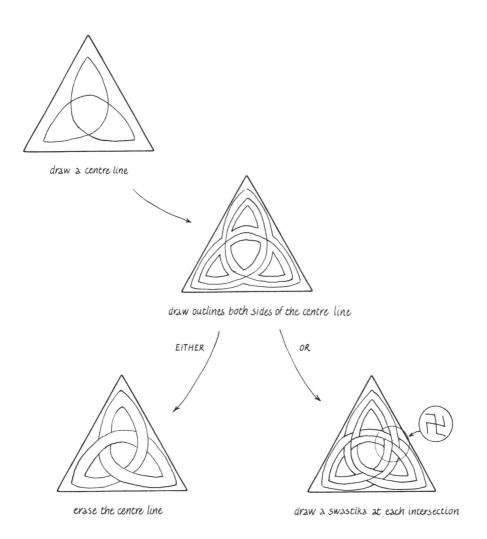

draw a centre line

draw outlines both sides of the centre line

EITHER

OR

erase the centre line

draw a swastika at each intersection

Doodling

can produce
intriguing knots

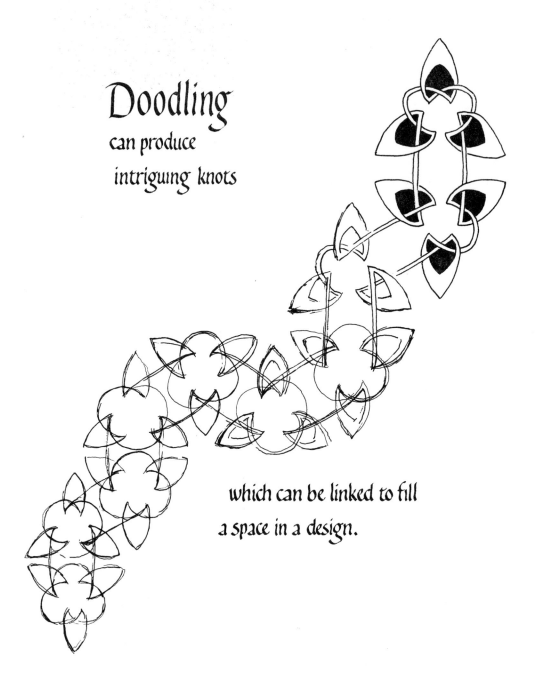

which can be linked to fill
a space in a design.

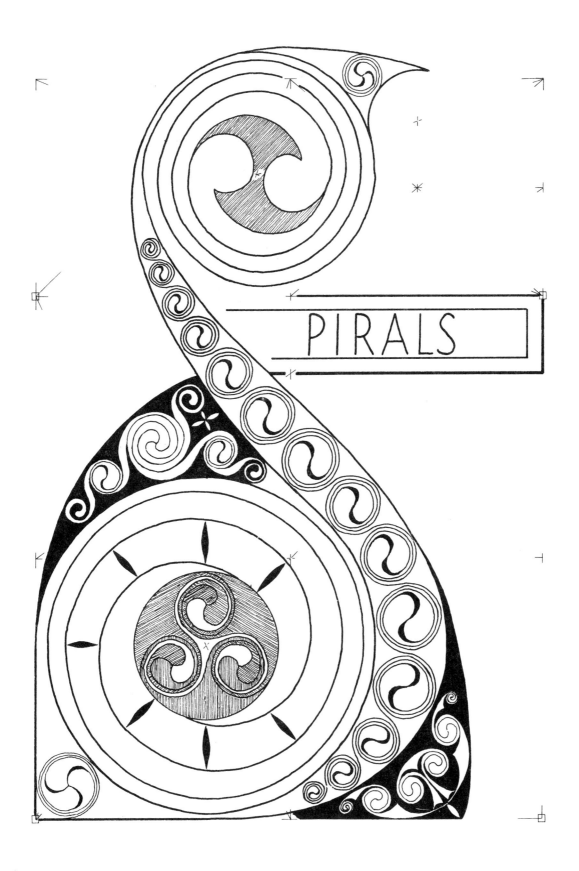

PIRALS

Spirals

are the dominant decorative motif of the most flamboyant pages in Insular manuscripts but their construction is remarkably simple and well described by Romilly Allen.

"All that it is necessary to do is to fill in the surface to be decorated with circles of any size, leaving about the same distance between each; then connect the circle with S- or C-shaped curves; and, lastly, fill in the circles with spirals working from the tangent points, where the S or C curves touch the circles, inwards to the centre. As the size of the circles is a matter of no importance, a surface of irregular shape may be covered with spiral ornament just as easily as one of symmetrical shape."

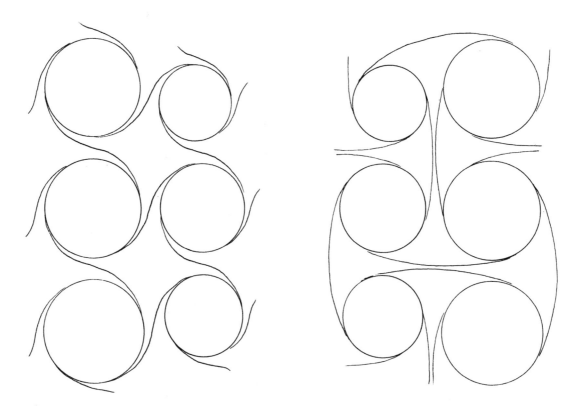

Spirals have three elements:

- the number of coils

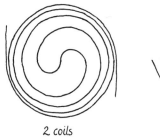 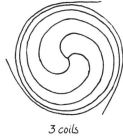 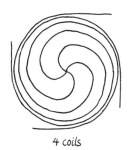

2 coils 3 coils 4 coils

- the number of times the coil turns

1 turn 1½ turns 2 turns

- the centre. Commonly used centres in manuscripts are:

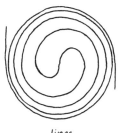 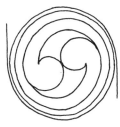 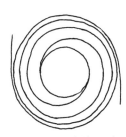

lines swelled lines buds a circle, which can be
filled with another spiral
or any other ornament.

For small spirals the coils can be drawn by eye. Large spirals are best
drawn with guide points. Work all the coils in together.

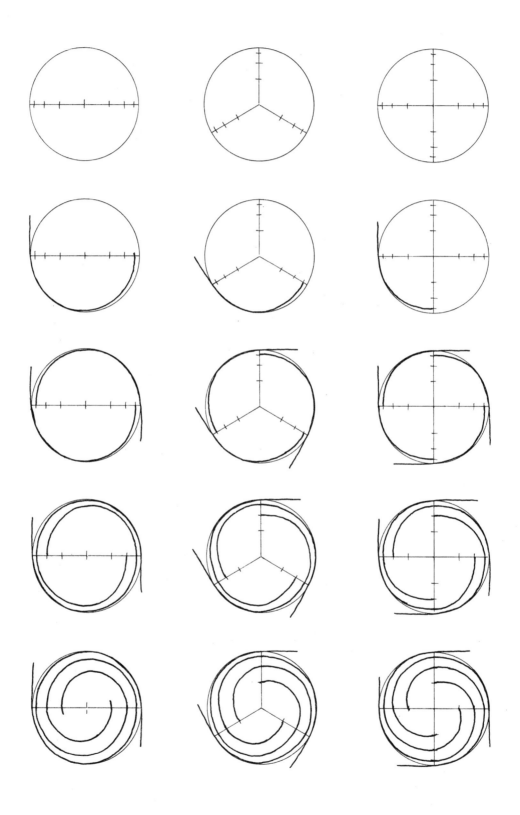

Equally spaced guide points look right if the centre is a circle,

but with lines at the centre the spiral will look like a lollipop.

The lollipop effect can be avoided by placing all the guide points close to the circumference,

or by spacing them in a Fibonacci sequence; 1, 2, 3, 5, 8, ...
For example, with a radius 15 mm and 3 guide points

Distances from the circumference are radius ÷ 11, radius × 3 ÷ 11, radius × 6 ÷ 11

= 15 ÷ 11 , 15 × 3 ÷ 11, 15 × 6 ÷ 11

$$= \quad 1 \cdot 4 \, mm, \; 4 \cdot 1 \, mm, \; 8 \cdot 2 \, mm$$

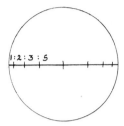

or with a radius 15 mm and 4 guide points

Distances from the circumference are

$$radius \div 19, \quad radius \times 3 \div 19, \quad radius \times 6 \div 19, \quad radius \times 11 \div 19$$

$$= \quad 15 \div 19, \quad 15 \times 3 \div 19, \quad 15 \times 6 \div 19, \quad 15 \times 11 \div 19$$

$$= \quad 0 \cdot 8 \, mm, \quad 2 \cdot 4 \, mm, \quad 4 \cdot 7 \, mm, \quad 8 \cdot 7 \, mm.$$

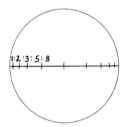 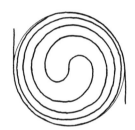

If the distances for the Fibonacci sequence are measured from the centre instead of the circumference then a snail-shell spiral is produced.

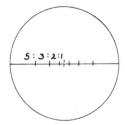 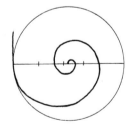

When buds are at the centre the guide points are best placed at:

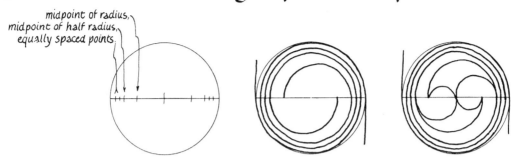

midpoint of radius,
midpoint of half radius,
equally spaced points.

Gaps in a spiral ornament can be filled with lens shapes or a cusped curve on a C-curve. Trumpet shapes can be used to change direction or to swell an S-curve.

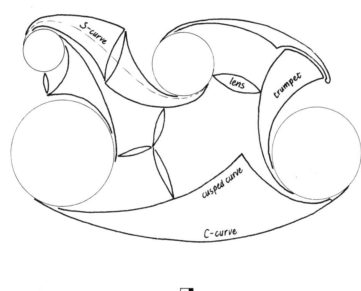

Spiral patterns can also be drawn with circles that touch.

· A band of two coil spirals.

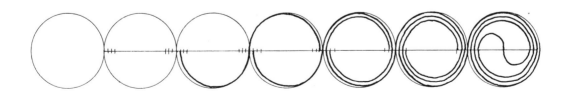

· A panel of three coil spirals

Rule up a grid of equilateral triangles:

1. measure the width of the panel at 60°,
2. decide how many circles are required across the panel,
3. calculate an interval = width ÷ (2 × number of circles + 0.3)
4. mark off the intervals from the centre (leaving a slightly larger interval at the edges),
5. starting at one side, rule lines parallel to the edge of the panel through alternate marks,
6. complete the grid with a 60° set square.

For example, with a panel 51 mm across,

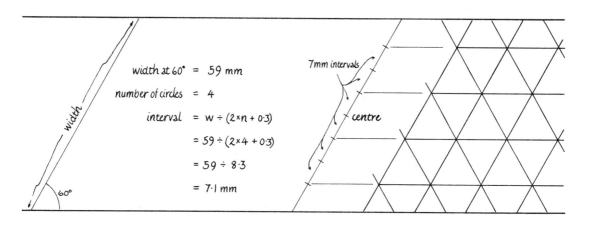

width at 60° = 59 mm

number of circles = 4

interval = w ÷ (2 × n + 0.3)

= 59 ÷ (2 × 4 + 0.3)

= 59 ÷ 8.3

= 7.1 mm

7mm intervals

centre

60°

width

Draw a circle at each intersection. Mark the guide points on one radius (any one) and then work through the panel marking three radii in each circle, making sure each marked radius joins another marked radius. Not all circles are marked at this stage.

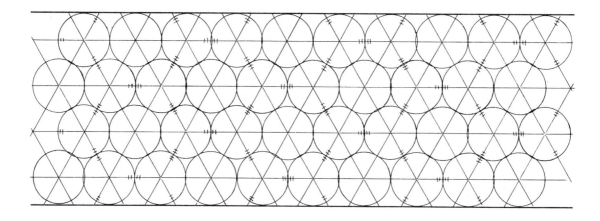

Fill the marked circles with spirals.

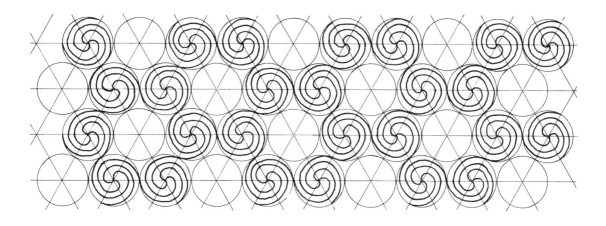

Complete the blank circles by working back from the middle of the S-curves.

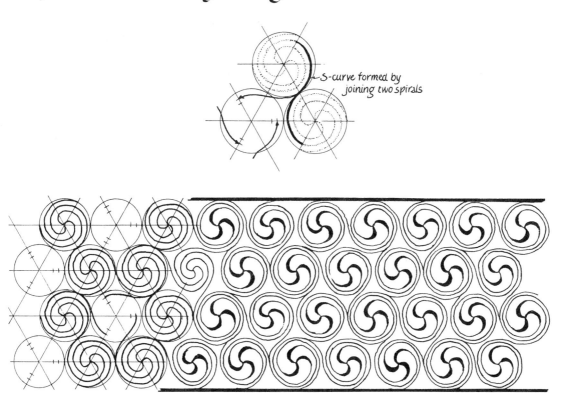

S-curve formed by joining two spirals

Having seen how to fill a panel, it is a simple matter to fill a circle with seven spirals. Divide a diameter into six equal parts and then rule up a grid of equilateral triangles.

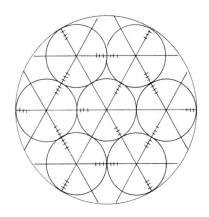 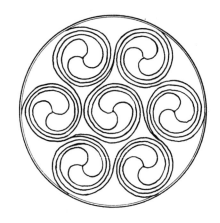

Four coil spirals are easily constructed on a square grid.

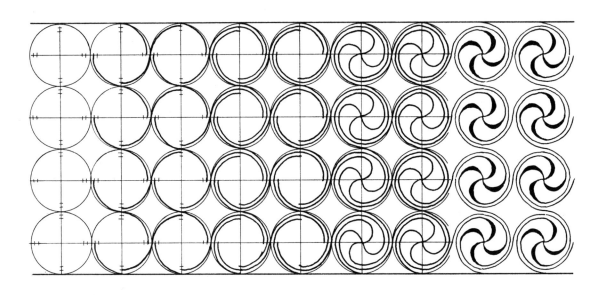

Zoomorphics

Zoomorphics

Zoomorphics and anthropomorphics, animal and human forms, can be copied from reproductions of Insular manuscripts. When designing original forms always start with the eye and capture the expression you want. Nothing will save a drawing where the eye is not right.

This example, derived from the beard pullers in the Book of Kells, I used to illustrate the third verse of Lewis Carroll's *Father William*.

The compass-drawn eyes that stare out, as if from another world, from the portrait pages of the Book of Kells are precisely placed on the page. The centres of the circles, exactly on a construction line, can be seen in Kells f7v and f28v.

eyes of the Virgin

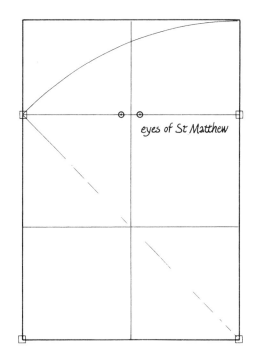

eyes of St Matthew

The constructions are described on pages 24 and 26.

Because zoomorphics are mostly free form rather than geometric their success will depend on how well, or perhaps how badly, you can draw. To capture the character of Celtic illustrations you should show a droll disregard for anatomy. Human forms can be drawn with two left feet, four toed feet, six fingered hands, dislocated shoulders, or impossibly interwoven legs. In the example above I have placed the big toe on the outside of the foot. I thought it looked better that way.

The finished work

Only a few rectangles have been used in this book for the construction of page designs. Calligraphers should choose rectangles that give their finished work a shape that suits the text.

A systematic classification of rectangles

· Simple square root rectangles

asymmetric symmetric

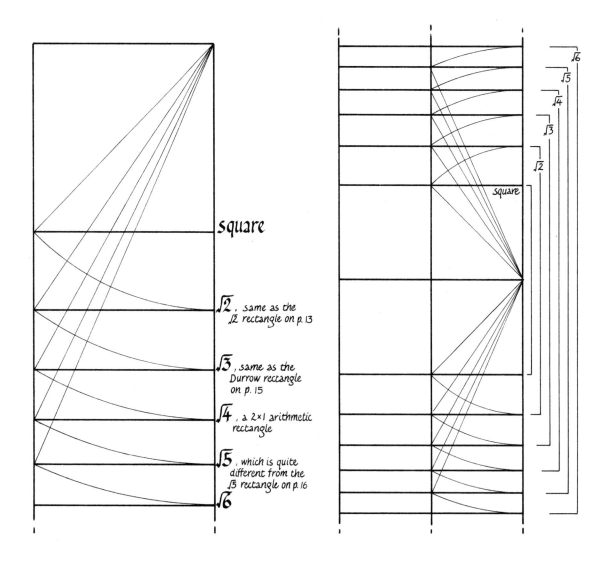

square

√2 , same as the
√2 rectangle on p. 13

√3 , same as the
Durrow rectangle
on p. 15

√4 , a 2×1 arithmetic
rectangle

√5 , which is quite
different from the
√5 rectangle on p. 16

√6

· Compound square root rectangles

asymmetric symmetric

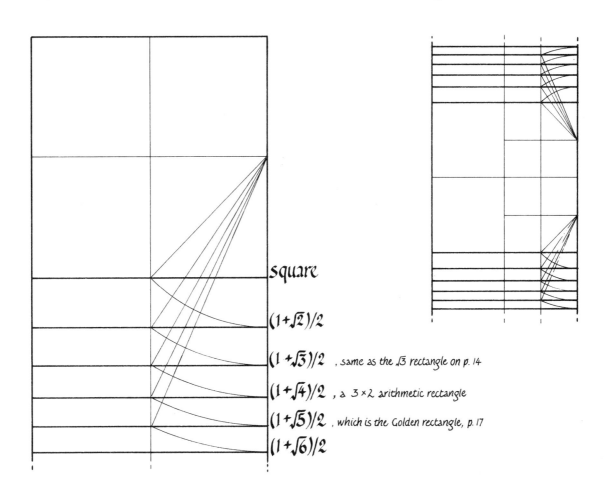

square

$(1+\sqrt{2})/2$

$(1+\sqrt{3})/2$, same as the $\sqrt{3}$ rectangle on p. 14

$(1+\sqrt{4})/2$, a 3×2 arithmetic rectangle

$(1+\sqrt{5})/2$, which is the Golden rectangle, p. 17

$(1+\sqrt{6})/2$

Sample work

If we accept Jan Tschichold's dictum about non-arbitrary proportions, then the method I have described for setting out a design should always produce aesthetically pleasing results. A simple rectangular design is easily achieved and is suitable for proverbs and short quotations, like the frontispiece and the colophon. More difficult are designs where the rectangle is not obvious, for which the best example is the chi-rho page of the Book of Kells.

The quotation on the three following pages is from a 12th century

author who may have been describing the Book of Kells. The page designs are based on a rectangle with sides in the ratio $1 : (2\sqrt{3} - 1)$.

The text for page 94 is from *Up Here on the Hill*, a book of poems by Bub Bridger, who is part Maori and part Irish. The panel at the bottom of the page contains a Celtic tree key-pattern that merges into a Maori kōwhaiwhai pattern.

from

Gerald of Wales

Giraldus Cambrensis

Topographia Hiberniae

Dr E. H. Alton's translation

Fine craftsmanship is all about you, but you might not notice it. Look more keenly at it, and you will penetrate to the very shrine of art.

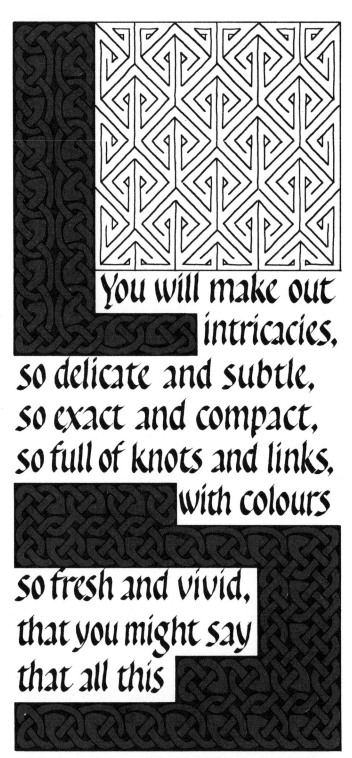

You will make out
intricacies,
so delicate and subtle,
so exact and compact,
so full of knots and links,
with colours
so fresh and vivid,
that you might say
that all this

was the work of an angel,
and not of a man.

For my part
the oftener
I see the book,
and the more carefully
I study it,
the more I am lost
in ever fresh
amazement,
and I see
more and more
wonders
in the book.

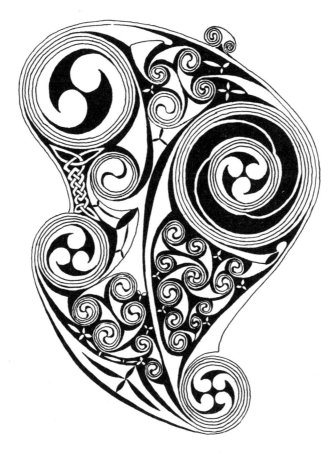

At seventy-two
My father died dancing
And
I don't know
A better way to go
Than that
Life wasn't good to him
Nor he to it
But in the end
He did the thing
With such style
And grace
Dancing an Irish jig
With joy
In his face

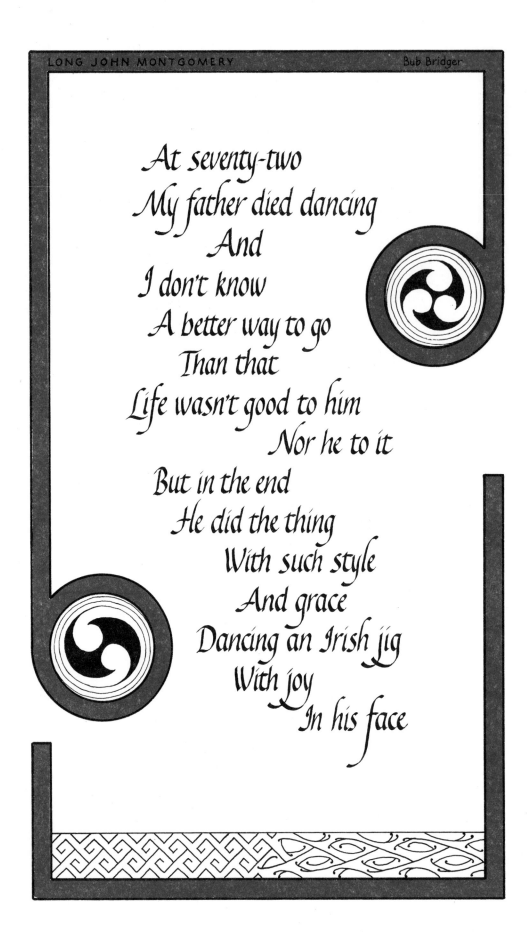

BIBLIOGRAPHY

FOR REPRODUCTIONS

MICHELLE BROWN, *Anglo-Saxon Manuscripts*. British Library, 1991. Contains a reproduction of the Durham Cassiodorus *f172v*, clearly showing the step patterns.

PETER BROWN, *The Book of Kells*. Thames and Hudson, reprinted 1985.

FRANÇOISE HENRY, *The Book of Kells*. Thames and Hudson, reprinted 1988. Reproductions at about natural size of 93 full pages and 6 half pages together with 30 plates of greatly enlarged details.

BERNARD MEEHAN, *The Book of Kells*. Thames and Hudson, reprinted 1996.

BERNARD MEEHAN, *The Book of Durrow*. Town House, 1996. My construction on pages 22 and 23 will match the reproduction of *f1v* if the initial square has sides 125 mm.

CARL NORDENFALK, *Celtic and Anglo-Saxon Painting*. Chatto & Windus, 1977. Contains a reproduction of Book of Durrow *f1v* and Durham Cassiodorus *f172v*. The Durrow *f1v* should match a construction where the sides of the initial square are 123 mm.

FOR FURTHER READING

GEORGE BAIN, *Celtic Art*. Constable, 16th impression 1993. This book, first published in 1951, contains clear illustrations of patterns which can be difficult to decipher in reproductions of the manuscripts.

IAIN BAIN, *Celtic Key Patterns*. Constable, 1993. An encyclopaedia of key patterns with clear instructions on how to construct them.

IAIN BAIN, *Celtic Knotwork*. Constable, reprinted 1992. Much useful discussion on the nature of knotwork.

AIDAN MEEHAN, *Knotwork – The Secret Method of the Scribes*. Thames and Hudson, reprinted 1995. A detailed description of the dot method. It is worth knowing the dot method as it is handy for filling little odd shapes that can occur in a design. You may even find it is your preferred method for filling a rectangular panel. Meehan has written a series of books on Celtic ornament, all of them worth delving into for ideas both practical and mystical.

J. ROMILLY ALLEN, *Celtic Art in Pagan and Christian Times*. Methuen, 1912. Originally published in 1904 and republished by Senate, 1997. Some of Romilly Allen's work has also been republished as an appendix to Meehan's book on knotwork and Bain's book on key patterns.

ANDY SLOSS, *How to Draw Celtic Knotwork*. Blandford, 1995. Sloss invented a simple method for constructing knots while working on a computer program to draw knotwork. The program can be purchased. The method is explained in some detail, with an analysis of the number of patterns that can be produced. Many of them will not look especially Celtic.

ROBERT D. STEVICK, *Page design of some illuminations in the Book of Kells*, in *Book of Kells: Proceedings of a conference at Trinity College, Dublin, 6–9 September 1992*. Scolar Press, 1994. *A Geometer's Art: the full-page illuminations in St. Gallen Stiftsbibliothek cod. sang. 51, an insular gospels book of the VIIIth century*. Scriptorium 44 (1990): pp. 161–192. *The Shapes of the Book of Durrow Evangelist-Symbol Pages*. The Art Bulletin, LXVIII (1986): pp. 182–194. These are scholarly works describing the methods for setting out pages. Stevick is attempting to reconstruct, from the evidence available, the exact methods used by the ancient scribes. My purpose is to show how a modern calligrapher can produce similar work.

ROBERT D. STEVICK, *The Earliest Irish and English Bookarts Visual and Poetic Forms before AD 1000*. University of Pennsylvania Press, 1994. This is not easy reading. Here Professor Stevick is writing for scholars in medieval poetry but calligraphers who struggle to read even some of the book will be well rewarded for their effort. Stevick's discoveries are quite startling.

JAN TSCHICHOLD, *Non-arbitrary proportions of page and type area*, in *Calligraphy and Palaeography*, ed. A. S. Osley. Faber & Faber, 1965. A valuable study of the proper size and shape of a book.

MARK VAN STONE, *Ornamental techniques in Kells and its kin*, in *Book of Kells: Proceedings of a conference at Trinity College, Dublin, 6–9 September 1992*. Scolar Press, 1994. Worth reading for the argument for the dot method of drawing interlace. I do not find it entirely convincing.

go
n-éirí
an bótar
leat